Sylvia,

May God Bless You!

Patricia Miller

What in the World is Next?

The Empowerment of a Black Woman

by Patricia Miller

ISBN 978-1-62806-183-3

Library of Congress Control Number 2018953095

Published by Salt Water Media
29 Broad Street, Suite 104
Berlin, MD 21811
www.saltwatermedia.com

Cover image used courtesy of unsplash.com user Adam Tagarro

*Show me your ways, Lord, teach me your paths.
Guide me in your truth and teach me, for you are
God my Savior, and my hope is in you all day long.*

- Psalm 25:1-10

Tiffany

Tarra

Dedication

To my daughters, Tarra and Tiffany, who are the love of my life. They have both been an inspiration, blessing, and friend to me. These two young women exhibit what a fine outstanding woman should be and they possess such great qualities along with excellent work ethics. In time of need and distress, I know they will always be there for me. They have made my life complete.

To my family and friends: thank you for always being there for me. Whenever I have felt as if my world was about to end, you were there to pick me up and strengthen my pathway. It gives me honor and much pleasure to have had such great people in my life with steadfast love and friendship.

To all women, regardless of race, color or creed, I present you with the empowerment to take charge of your lives. Life for you is there for the taking. So reach out and take charge of yourself, prove to yourself that all things are possible if you only believe, experience things for yourself and above all educate yourself so that you can be self-sufficient. Always have that positive attitude of yourself with you each and every day and it will let your light shine to guide you along the way.

A Dedication to all of My Former Students

Many of you have expressed the desire to put your life into words. Simple enough, I tell them to write a book! This is the one statement that seems to spark an intest to them! Since they all think they can write, why not give it a try! The first thing that I tell them is, they should start early on by keeping a journal about their lives. I inform them that they should keep track of important facts, details, and events that occur in their lives. The journal should also include their dreams and any goals they may have. To compile enough information to make your book a "hit" it may take you a few years to complete it with all the research and information needed to make it interesting! It should be very appealing to your reader. Even though it's about your life, have a sense of humor to filtrate the factual information.

Since women buy most books, write directly to your reader! Beware not to flaunt your vocabulary or use inside jargon. Remember that most people read on an eighth grade level. Also, vary the length of the sentences and make frequent paragraph breaks. Keeping all these hints in mind, go for it! Start sharing you

and pour out your inner most thoughts of your life! I can remember just writing one day and the writing turned into eight hours that day! From that day on, I knew I needed to put a timeline on my writing time. So I tried to dedicate at least a few hours a day to add to my book. Guess what! I put the written mansucript of my book away! About three years later I pulled it out and re-read it. I felt it was now the time to type, with some corrections, additions, and modifications and submit this book to a publishing company! So I did! And I'm thinking, "What in the world is next?"

Part One

Life no matter how wealthy we may become, what path we may take to gain our fame, what obstacles we may face, we can never escape the memories of our roots. Memories are like a plague, hard to escape and returning to infect us seasonally if we are not strong enough to move and become empowered by the strength and wisdom from whence cometh our strength. Some of us waddle in poverty only because we lack self-confidence. We have the lack of self-confidence because we role-model and emulate what we see in our daily environment. My parents, my grandparents, and my great-grandparents were all poor, however, they possessed excellent work ethics. Therefore, I acquired these same work ethics, because it was instilled in me, that the only way you would have anything was to work hard. My ancestors had very little education but they made sure the lives of their offspring would be well-rounded and have an education so that we would be self-sufficent and have careers, which would enable us to stand up and be the proud people we are!

My memories always drift back causing me to reflect upon the many changes and paths my life have taken. The courses of my life seem to change from time to time, constantly reminding me of my beginnings, which to some may seem a life of "turmoil." Growing

up in a rural area, an all black community with little money or monetary gifts, only major household necessities--hand me downs from the white people my parents worked for, even though we had a lot to eat, it still made me want to better myself with an education to enable my children to never have to look back and think of the sorrow that was embarked upon me! As blacks we always had great meals, due to the fact that my Memaw, Popaw, and my Dad raised chickens, ducks, and hogs. We were ecstatic at our huge meal times! However, thinking back they were not nutritious at all! Those meals caused us to become obese, have high blood pressure, become diabetics and even have other diseases. But even with the poor diets, we were taught to be proud people and to never forget from "whence we cometh."

During the years of growing up we were plagued with prejudism of being black and living in a white man's world. From the food we may have sometimes gotten that was left over after the whites served it at huge festive occassions they may have had, to hand me down clothes that our parents may have recieved after cleaning their houses, the old textbooks which the black schools were donated once the white schools purchased the newer versions of the textbooks, having to eat in the colored section, use colored only bath-

rooms, and that setting in the back of the bus, which one of our famous Black Americans, Mrs. Rosa Parks so eloquently addressed and paved the way for us! So now you see why during those early fifties and sixties, I felt this was in deed a white man's world! Even though God told us that He did not send His son into the world to condemn the world, but that the world through Him might be saved. (John 3:17)

I was born in a family where my mother and father married five months before my birth. Needless to say, this was probably the ending of a sad beginning. My father was a from a huge family and since he was the oldest he had to quit school to help his parents support a family of fifteen! Therefore, he had a limited educational background and he could only get jobs that required little or no skills. However, due to the draft that the the armed forces had enforced, he was drafted into the Marine Corp. This was of a great benefit to him since it enabled him to complete his education and become a cook in the mess hall for the Marines. My dad was a proud man and going into the Marines caused him to gain a lot more self-confidence. What a man he became! Mom on the other hand came from a family who during this era were quite well-off for black people. Her father was a foreman at a logging company and a part-time

local preacher! He could be a scoundrel as I recall... Mean as all get out if he had a bottle of his favorite sherry wine! My grandmother, his wife, was the most adorable creature, almost angelic. She loved everyone and she was loved by all who met her. Memaw's, as we called her, father was a Cherokee Indian which caused my grandparents to have an offspring of radiant children of light olive complexion with the most beautiful straight black hair and gray eyes. During his time period, if you had light complexion and "nice" hair, you were considered to be very upright and held at a higher status.

Know that the Lord, He is God;
It is He who has made us, and not we ourselves,
We are His people and the sheep of His pasture.
- Psalm: 100:3

My mother was very smart and during her school years she was an honor student. Her life-time dream was to be a teacher, that is until she became pregnant with me! Mom was the apple of the superintendent's eye. Mrs. Donalds took immediately to her because of her brains and beauty. She had high hopes of my mother continuing her education and becoming a teacher and maybe in time stepping into her shoes as

superintendent! She had expressed many times to my grandparents about my mother furthering her education at a Teacher's College. My mother met my father and those plans fell through, she fell in love? Until the day I was old enough to remember, I felt it was my fault that she was unable to pursue her educational career! Or was I made to feel that way? So I promised myself that I would be a good girl and become a teacher, since it was me who I felt caused my mother to have to work at meager jobs. She would clean houses, baby sit, iron clothes for white people, she worked in factories and did any other odd jobs to make ends meet. Guilt continued to be my master, as I saw how hard my father worked, also. It seemed he worked just as a slave, only without being whipped, chained and shackled! Dad, too, worked at many jobs...farming, logging companies and then one day, "BINGO!" he landed a job driving an oil truck for one of the leading oil companies in our town. Of course we thought we were rich! However, we continued to live in the projects, where my brother and I shared the living room sofa as our bed and bedroom. I had such a great imagination that I would pretend the top half was my bed and the bottom half was his bed.

For you know the grace of our Lord Jesus Christ, that
though He was rich, yet for your sakes He became poor,
that you through His poverty might become rich.
- 2 Corinthians: 8:9

It was during this time, when I was about six years old and my brother was five that my mom and dad started having martial problems. Again that guilty horse reared his ugly head and I felt it was my fault! They fought viciously for days. We tried to stop them but it did not work, we then would run to our safe corner. When the fights got really too much for us to bear... throwing of glasses, breaking dishes, chairs sailing through the rooms, even sometimes gun firing, I would grab my little brother and run down the street to, my "rich" godparents's house. We called them "rich" because they owned their house. They had children the same age as my brother and I. This family was simply a God sent to me and my brother. We often spent safe and happy days with them! Still mom and dad continued to argue and fight injuring and ridiculing one another both mentally and physcially.

A fool's lips enter into contention, And his mouth calls
for blows, A fool's mouth is his destruction,
And his lips are the snare of his soul.
-Proverbs: 18:6-7

My godparents were gracious and kind to my brother and I in our time of distress and need. Things seemed to settle with my parents for a while. At least they were being civil to one another. It made me and my brother feel better about ourselves and we both were happy once again. My mom and my godmother, Gardenia's mother, arranged a shopping trip for the two of us to get new clothes. This was our first year in school and were thrilled to get new clothes. Mom bought me some lovely things for school! She was now working for two entrepreneurs that owned stores in our town, "Saks" and the "Inlet". Once again my brother and I had a sense of belonging with our home feeling happy and safe. As you know children are very resilent and can bounce back especially when their parents are involved. I was very wise and grown-up for my age and started noticing patterns with my parents martial behaviors. Every Thursday, Friday and Saturday the agruments would began. My mother was always the aggressor! I almost think she liked being punched, slapped and knocked around by my dad!

But You are He who took me out of the womb; You made Me trust while on My mother's breasts, I was cast upon You from birth. From My mother's womb, You have been My God.
- Psalm: 22:9-11

19

Even though all of these turmoils existed in my life, I was very successful in school. Gardenia and I did our homework together and we would sit and talk for hours about growing up and going to college together. One day we would even live together in a huge mansion and live happily ever after! I guess we had heard too many fairy tales. During my first year of school my godmother was a housewife so she babysit my little brother. He was such a joy to be around, always smiling, joking around and saying silly things. He was so devilish and maybe some of the effects of my parents martial problems could be coming out through his actions. He would take the cat and pull his tail until he screamed. He even tried to set the cat on fire! One day he shot me in the ear with his BB gun and laughed so much he peed himself. But at the end of the day we would make up and his little innocence would come floating back. I would always have him get on his knees at night and we would pray: "Now thy lay me down to sleep. I pray the Lord my soul to keep. If I should die before I wake, I pray the Lord my soul to take." During the time of any arguments, which always turn into a fight between my parents, I found myself as I got older praying more and more and thinking " What in the world is next?"

As my mother and father continued this esca-

pade of fussing and fighting, they were unaware of the damage that they were causing their own children. Did they not realize that we were always there listening, watching and asking why were they doing this? My godparents never did anything like this in front of their children. But our parents did it so often, evenually we thought it was okay and maybe a little normal to act that way. Around my second year in school and my brother's first year of school , something awful happened. Mom thought that since she only did seasonal work at the tomato factory in the summer, we could stay home alone and help around the house by doing a few chores. WRONG!!! She gave us specific instructions to stay inside of the apartment, keep the place clean and neat, wash the dishes; which we had to stand in chairs to do, clean the bathroom and only eat foods from the refrigerator that required no cooking! Quite a bit for a seven and six year old. However, we thought not a problem, we can do this. So when she left we quickly started to imitate what my mom and dad did when they fought, right down to the cursing and fighting! We thought it was okay no one ever told us any difference! This continued daily when mom would leave. If one of us got hurt, we would apologize and stop! For children that was not normal, I know this now as a teacher, we

21

needed some type of intervention, but no one knew. My parents, also, needed to seek counseling for their behavior. My brother and I did this for years, not until we were grown-up, he in the army and me in college, did we come to the realization that imitating our parents was wrong? One day we sat and discussed some of things we said and did to one another and we did apologize and say how much we did love each other. We felt that we should have told someone about what we were enduring and maybe things would have been different--better! My brother was killed in an automobile accident, while home on leave waiting to be deployed to Vietnam.

During my second year in school my mom started letting me stay with my grandmother and my aunts from time to time. My brother would stay occassionally, however, he preferred being home with my parents, maybe feeling they wouldn't fight or argue. Once I was around other adults and seeing no signs or hearing no agruments or fighting, I knew then that the trama we had been experiencing was not NORMAL! My memaw and popaw had a loving and wholesome home and I enjoyed spending time with them. During that time my favorite cousin, Diamond, was living with my grandparents and had become my newest best friend! So of course, this became

the highlight of my life to be able to visit and play with my cousin and, aslo, to have a girl in my life... someone other than my brother! This I felt was a God sent act. I prayed a lot due to my life style with my parents always fueding, that God would bring some peace and happiness in my life. Diamond became just the anchor I needed to survive! She like me and my brother had been through a terrible ordeal. Both her mother and father were deceased. This left Diamond and her sister, Mystery, homeless. Diamond's father was my grandparents' oldest son, therefore when they went to the courts on Diamond and her sisters behalf, so did her mother's parents. The judge awarded Diamond to my grandparents and Mystery to her mother's parents. So Diamond spent most of her time with my grandparents and some time with my aunts. My heart bled for her, she was such a sweet child, only a year younger than me, but those big beautiful eyes made her appear much younger. There was a sense of wiseness and sadness in those eyes! I never wanted to leave her, once again I found myself wanting to protect her as I did my brother. At the end of each week-end, holiday or summer break my parents would come to get me from my grandparents' house. I would scream and cry so hard and run to my favorite hiding place, behind memaw's old recliner, that they

would give up and let me stay. What a joyous feeling would come over my entire body! I remember having hiding places in both my home and my grandparents home...was that my salvation or my security?

Soon my parents announced that they were having another baby. Wow! All I could think of was a baby having to endure what my brother and I had for the last several years...the sleepless nights, the cursing, the throwing of anything in sight , and us screaming, crying and running for help. However, those horrible thoughts soon slipped away, because for those next nine months there was no fighting and very little arguing, so I became estatic at there being a newborn in our house and a girl, maybe! One incident that clings to my mind was about a month before my mom's delivery, my dad came home from work late and very drunk. My mom started screaming and fussing and of course we retreated to our "hiding place," just in time to witness my mom slap my dad hard across the face! He grabbed after her, too late, she snatched a knife from the kitchen drawer and cut one of his fingers. The blood was everywhere, my brother and I ran screaming through the alley to my godparents house. Soon after we arrived there, we saw the ambulance going toward the projects. Later we learned that the doctors were able to stitch it up. Things in our house-

hold really calmed down after that horrific incident.

One night following that incident, I woke my brother and asked him to get on his knees and pray with me. I prayed and pleaded to God that my parents would never fuss or fight again. Well as I grew older, I did notice that there was less confusion in our household and a little more laughter and happiness! I continued to spend as much time as possible with my grandparents and Diamond, even as I entered my teen years. We were always in church since my grandfather was a minister. I still continued to pray that my parents would resolve their differences of useless and uncalled for violence. I often wondered why they stayed together...why not separate or divorce? It was not for me to question because God is above all things! One Sunday as I sat in church the minister read a scripture, which put everything I had endured in full perspective, like a light bulb turning on in my head! When I returned home from church I sat down and re-read the scripture and I began to understand!

If a wise man contends with a foolish man,
whether the fool rages or laughs there is no peace.
– Proverbs 29:9

My brother and I continued to visit our relatives whenever we could or were allowed to by our mom. Most of the time we would visit them alone, because our mother was a loner. She would rather be in the compounds of her own home, usually stowed away in her bedroom reading or scheming how to start an argument with my dad! For example she would say the darnest things, "some woman has left their underwear in my house, one of my gloves is missing, someome came in and stole my forks, why were you laughing with her in church, anything to "fuel the fire!" My youngest aunt and her husband lived in a neighboring state north of us, and they were fun to visit. We did so many things while with them it would be impossible to name them all. I can remember the beautiful cakes, pies and cookies she made. We were always involved with the decorating of her master pieces. She made the best seafood dishes which had a taste of a "magic potion." We played cards sometimes until the wee hours and my uncle would cheat us, but we did not care, we were having fun! I can never remember a time that my aunt and uncle ever argued or had a cross word to say to one another. I know they were human and probably had some disagreements, but they did it in the privacy of themselves. I would go to bed at night and dream of having a life like theirs. My

oldest aunt had two teenagers, Clara and Billy, I really enjoyed hanging out with them. It made me feel like I was as adult! I can remember our aunt loading us up in her car and taking us to the drive-in movies on a Saturday night. She would fry chicken, pop popcorn and make us jugs of kool-aid, this would save her from spending too much money, since it was so many of us. Aunt Betty would repeat this same menu when she took us to the Ocean View during the summer. She would set up things on the bench near the boardwalk and when we tired of being in the water or riding on rides, we would run to her to eat. She always had enough money for us to buy one treat!

The funny thing about her marriage was that her husband, even though he worked hard and would bring lots of great foods home; he would get all dressed, wearing his wide-brimmed hat and fine clothes every week-end and drive away in his sleek, shiny, cadillac and go out. He would always come home in the wee hours of the next morning. I was usually awakened by the loud noises that were made when he returned home. Even with this type of behaviour, they got along very well! They always seemed happy and acted like "best friends." As I think back, maybe they were "only best friends." My aunt's daughter was nice but she did have a mean streak! She would provoke fights

with her brother, who would try to avoid her at all times. Once Clara made some taffy and if you know anything about taffy it is an extremely hot boiling mixture. You have to butter your hands before pouring it into your hands to start the pulling process. As Billy was greasing his hands Clara took the pot of taffy and quickly poured it onto Billy's hands and arms. He squealed such a peircing sound, that we just stood there in disbelief! He ran outside to bury his hands into the sand, which was hot since it was summer! We just starred in astonishment at what we had just witnessed! I burst out crying to see how much pain Billy was in. She just flipped her hair back and said what a terrible accident it was. OH NO! We all knew it was not an accident, but we were too afraid to say anything. Billy ran and hid out until my aunt came home from work. He told his mother what had happened, when she approached Clara, she commented again, oh such a horrible accident and walked off to her room, flipping her hair again! As she glanced back, she had such a wicked smile on her face. The look seemed to say, you'd better not open your lips to say anything or you'll be sorry! Of course we were too scared to say anything. My aunt took Billy to the doctor and he had sustained second degree burns on his hands and lower arms. From that incident, I still

today hate taffy. And do you think Clara ever apologized to Billy? No she did not. I thought to myself, what in the world is next?

Like a madman who throws firebrands, arrows, and
death. Is the man who deceives his neighbor.
And says, "I was only joking!"
- Proverbs 26: 18-19

As time went on and my baby sister grew older, my parents seemed to settle down and have less problems of getting along. They decided it was time that we got a larger house, so we rented one in the country near my grandparents and some of our other relatives. My brother and I were thrilled because we finally had a bedroom with real beds to sleep on, not the foldable sofa! Things were better for a while and they even started taking us to the drive-in movies, which reminded me of my aunt and the fun we had with her when we went to the movies! My parents even hired the contractors that built my oldest aunts' house to build us a "brand new house!" Of course, we thought we had died and went to heaven. We were now in the neighborhood with my aunts, memaw and popaw. Mom and dad still had a few flare-ups, but they were not as awful as they had been in the past! As a matter of fact, since my sister was born

things actually were tolerable around our house.

Moving day came and we finally moved in our new house! There was a bathroom... since moving from the projects we had an outdoor toilet which I hated with a passion! Besides using the outdoor toilet, we had a pump, where we got our water from and we had to bathe in a foot tub! I know this sounds ancient, but it actually was a reality in some homes in the fifties. I lived with this and accepted it because these were things that my grandparents had in their household, which I came to love while staying with them. Mom brought me used furniture, which she stripped and painted white. How beautiful it looked! She then hung pretty pink drapes with matching throw rugs, since the floors were hard wood. I felt that I was in a dream and never wanted to awaken. Since I had a sister now we had bunk beds topped with strawberry pink spreads. My brother's room was, also, so cute! He had a maple bedroom suite, with a desk and blue accessories. He was as proud as a peacock, with a smile from ear to ear! That night, after moving in, I fell on my knees and thanked God for what he given to my family and that he would continue to smile upon us with all his rich blessings. Although I was early in my teens this verse stayed in my mind.

Lord, our Lord, How excellent is Your name in all the
earth, Who have set Your glory above the heavens!
Out of the mouth of babes and nursing infants,
You have ordained strength, Because of Your enemies,
That You may silence the enemy and the avenger.
-Psalms 8:1-2 O

Life was good and for the first time in a long time I felt that things were really going to finally change for the better! My cousin Diamond was now living with another aunt, but we still met up on week-ends at our grandparents' house. My oldest aunt lived next door to my grandparents, so we spent a lot time at her house, also. Her daughter, Clara, introduced us to paper dolls that summer. It was so much fun! We would visit one of our great-aunts, who would save us her ordering catalogs. From those Clara would show us how to cut out the dolls, cut out their clothes, and build and furnish the dolls' houses. We even made them cars. Sometimes Clara's mother would come in her bedroom and pretend she was a big storm and blow our paper dolls and their homes everywhere!!! How my aunt would laugh herself to tears. We, too, would scream out with laughter, running around the room trying to catch our paper dolls, Once again I whispered, "God is good. All the time."

However things started to take a downward spiral! My oldest aunt's husband who I had noticed that they had a strange relationship, was now my new next door neighbor. So I was around him a lot since I enjoyed being at my aunt's house, as all my cousins did. One day I went to the bathroom while at my aunt's house, when I came out her husband was standing by the bathroom door. I was so frightened I ran from the house! I did not tell anyone because I was too afraid to. I had never experienced anything like that in my life. That night as I as I closed my eyes to go to sleep, all I could see was his evil smile! I was a child, nothing like this was suppose to happen to children! I did not visit with my aunt or Clara for a few days. When asked why I had not been over in a while, I lied and said I had not felt well. I, also, made sure to never use their bathroom again, unless someone went with me. From that day on each time I would see him, he would flash that same smile at me, which I grew to hate! Diamond and I found a new place to play. There was a path behind our grandparents and my aunts' house. It was lined with pear trees. The white blossoms in the spring made it look like a playland. This became our personal play area, that we called the "path." This path was adorned with beautiful pear trees and during the late spring and summer, we climbed the trees and got

the pears to eat and for our grandmother to preserve. This path lead to to our great uncle and aunt's house. They were best friends with my grandparents. Uncle Matt was my grandfather's brother. We loved going to their house because aunt Ella made the best gingerbread cookies in the world! One particular day we were playing with our dolls in the path when we heard a low whistle. As we turned around to see where it was coming from and who it was, there stood our aunt's husband leaning against one of the pear trees with that smile! We grabbed our dolls and ran to Uncle Matt's house. He ran after us, not knowing that our uncle and aunt had returned from shopping early. We banged on their door and it opened, our aunt's husband vanished in the woods! When uncle Matt asked why we running and banging on the door so hard, we lied and said the rooster from our grandparent's house was running after us.

As Diamond and I walked back home, we discussed what had happened. During that era it was a no-no to talk about things like. But we were too scarced to tell anyway! I remember having a friend in the community who told that she had been molested and raped by her older cousin. The people actually blamed "her" saying she was fresh and flippy around him. So in the fifties you learned to keep your mouth

closed and watch your surroundings! That night Diamond and I prayed that nothing like this would ever happen to us. We wondered, what in the world is next?

An evil man seeks only rebellion;
Therefore a cruel messenger will be sent against him.
- Proverbs: 17:11

That evil night turned into another perfect day! As children, things that happened were soon forgotten and we learned to move on into another day! Our grandmother worked during the summer months at a tomato factory in a neighboring town. She gave us specific details on what to do and what not to do. Of course we promised we would follow her directions... stay in the yard, lock the doors when we were inside, and stay off the highway! We kissed her good-by and waved as she boarded the factory bus. Knowing that we had lied to her, we immediately began to plot and plan our day! First, we pretended to be indians and gathered our belongings, crossed the highway and headed down the road to an open stream. We laid by the stream and drank the running water. We were told if the water was running in the stream it was safe to drink. We made a make shift teepee and pretended

to build a fire and sat with our legs crossed and sang songs and then danced around! As we grew tired of this game we returned home. We were hungry, so my brother took his bb gun and went outside and killed three blackbirds. Since we had always watched our grandmother kill and clean chickens we had no trouble preparing them. We followed her steps of scalding, picking the feathers off, cutting open the bird to remove the intestines and rinsing the birds thoroughly! This followed by using salt and pepper and flouring it before putting in the hot grease to fry. Each one of us ate one bird! They tasted very good, just like chicken. We were careful to clean up the kitchen and put everything back in the proper place. How smart was that for three young "tikes" ... very smart!

After lunch we would always have to wait for "Ice Man Mickey." Memaw did not have a refrigerator during that time, she had an ice box. The ice man came to your house three times a week and you would purchase a large block of ice for a quarter and sit it in the bottom of the ice box. Once the ice melted we would have to clean all the melted water from the ice box before the new block was put in. What a messy job that was! Besides being quite helpful around the house, we did many mischevious things during those summer months! But thanks be to God, when they

said he looks after babies and fools! Because he took care of us! One day we decided to thumb a ride to Mr. Leemond's store. This was a small convenience store about a mile from my grandparent's house. So we walked to the end of the road and stuck out up our thumbs. We were only playing, not thinking that anyone would really stop to pick us up! But out of the clear blue sky, a huge shiny black car stopped and started to back up toward us. Of course, we were petrified and proceded to run back up the lane toward toward the house like three scampering squirrels. Once inside the house we locked the door, which was only a wooden button lock, and pushed a chair in front of the door to secure it! Then we jumped on the sofa and peeked out the drawn curtains. The man drove up the lane and got out of the car. He then walked onto the porch and knocked on the door. We were so scared we almost peed our pants! With trembling hands and heaving breathes we continued to peek timidly and horrified out of the window! We were only inches from him and could hear his harsh breathing! He said in a cool calm voice, "little children, little children, come on out I'll give you a ride. Please come out and I will give you some candy, too! I promise I won't hurt you." All we could do was to cover our mouths to keep from screaming out in fear! During the 1950's

and 1960's there was little talk of kidnapping, child molesting or even rape. So many times when children became missing, the townspeople just wrote it off by saying the children ran away. They said this was due to the poverty level, which existed during that time and was more prevalent. Maybe because there was no welfare to speak of, no food stamps or independence cards, and vouchers for heat assistance! So when a child went missing the parents usually felt one less mouth to feed. We did learn a valuable lesson that day and we never spoke of what had happened and we never thumbed again! It was always a priviledge and honor to be able to go back to school and have some normacy in our lives.

However, remembering back to the summer before I entered high school I started doing field work. I worked in the tomato and cabbage fields. This type of work was defintely hard, especially for a thirteen year old. However, I was determined to stick with these jobs so I would have the proper clothing as my peers would have when returning to school. When filling the tomato baskets, they had to be piled high and moved over to a turn row where the tractors would pick them up, I barely could move the baskets, let alone put them into another row. Therefore, the boys who came from Florida and lived on Mr. Beaches la-

bor camp would help us, since they thought we looked so cute and wanted to talk to us anyway. And believe it or not, a little mischevious smile went a long way! But even with their help, it proved to be much too hard! Therefore, my grandparents took me with them to the cabbage patch that same summer. When working in the cabbage patch, you had to pull bunches of cabbage plants from the ground and count out one hundred and wrap rubber bands around each bundle of them. You had to fill a basket then move on down the row. They would be tagged and noted to your account. This was a little easier, but nothing I would want to do for the rest of my life! These jobs proved to me more and more that I had to get a good education and get out of these fields!

As one vegetable season ended, another one began! It seemed just like clock work. Tick, tock, tick, tock! The string bean field was another nightmare waiting to happen. You had to fill up a hamper and make sure it was topped off. Then you had to secure a top on the baskets using wire clamps. Needless to say, some days I only picked two or three! Not much money was made in that field. When getting only fifty cents a day, you see how much money was made! Next off to the pepper field! Well, picking of peppers was by far the easiest. The peppers were light weight,

so the baskets could be filled faster and moved around easier. Still this was not the job for me. The hot sun boiled down on your heads feeling as if scrambling your brain, the sweating, the horseflies and my attitude made field work impossible for me to adapt to!

There was a little reward in sight after working hard all week! My grandparents would load us up their old blue and white ford and off we would go to our near by town. We could hardly wait to hop out of the car and run to our favorite variety store, J.B. Newcastle. This store had everything you could think of under one roof! My first stop in the store was always the underwear section. I have always been a lover of beautiful "undies." Picking out the pretty panties and matching them up with the cute bras, made Diamond and I feel like grown-ups. We would giggle and shout with joy as we made our purchases! Before we left for home we would always visit the side street, which had different shops and ventors. There was a soda fountain where we would purchase hard packed ice cream, hot peanuts in the shells and popcorn, which we would take home to eat later while watching our favorite t.v. shows. We only had black and white televisions during this time and we would watch *The Lawrence Welk Show* and *Gunsmoke* every Saturday night. We hardly ever ate out, so once in a while our grandpar-

ents would treat us to a hotdog and soda pop before living the town to return home in the country!

Since we had worked hard all week, sometimes we were allowed to go the matinee movie on Saturday afternoons. We were so excited! We would dress up in our Sunday best and once at the movie, which was a quarter, we would purchase our popcorn and soda pop and head up stairs to our seats. During segregation all blacks had to sit upstairs, while the whites were allowed to sit downstairs. But we did not care as long as we were there and had some place other then home to go! We did not worry about it because that's just the way it was. We really enjoyed ourselves and talked about the movies for weeks to come. Sometimes my brother and some of the other boys would throw soda pop or popcorn down on the whites! WRONG! Then the manager of the movie would come upstairs with his flashlight shining it all around. We just sit there quietly, ignoring him and watched the movie. When he walked back downstairs, we would roar out with laughter. We were just being children and thought what in the world is next?

School opened and as they would say "we were all dressed to kill!" Our aunts were beauticians, so of course our hair was laying in place, with the newest style, the morsell waves with bangs cut to perfection!

The dresses we wore were "starched to the minute." My brother's pants were perfectly "creased," with his shirt collar, "stiff as a poke." The tennis we wore (which they would call bobos today), were pure white, layered with white bobby socks. This was my first year in high school and I knew it was going to be a blast! Lots of students, lots of teachers, and lots of other staff members adorned the school and hallways daily. I had never seen that many people in one place before. There were black students transported from five neighboring towns. We did not have a black school in each town as the white students did. They just threw all of us blacks together and we hoped for the best! Once again, it did not matter to us, because during that time, that's just the way it was!

Trust in the Lord with all your heart, And lean not on your own understanding; In all your ways acknowledge Him, And He shall direct your path.
- Proverbs: 3:5-6

I tried out for the for the majorettes and the cheerleaders upon arrival at high school. During those tryouts I started discovering my body. We had our gym classes with the boys and that was a little scary and fascinating! They were on one side of the

gym and we were on the other side and they spent most of the period watching our every move! Uncomfortable was not the word to use! When describing the way I felt as they from time to time would make comments about us and how good we looked. The emotional feelings that I felt caused my adrenaline to pump and me discover feelings that I did not know existed in a girl, especially one my age, my size...5 feet 5 inches tall, and even if I were wet maybe 70 pounds! I made both the cheering squad and majorettes. This was such an exciting time for me! I felt my worth had finally now come through!

During practice as cheerleaders, we always had to practice at one end of the gym, while the basketball teams would practice free throws at the other end of the gym. As we would run out on the gym floor, there stood those magnificent looking basketball players! The junior varsity were okay, but they were our ages. But that senior varsity, out of sight! Their bodies were so buffed up... nothing but mucles! They would yell and clap, as we practiced flips, twirls, splits and cartwheels, moving in ways that even caused some of the coaches to stop for a moment to take a look! The saying we were "built like brick houses" was new to me. I soon found out that it meant we had good shapely bodies. Each day this would go on until Mrs. Stump

would shout at us and give us one of her nasty looks, that could kill a dog and shout wipe those silly grins off of your faces! That was Mrs. Stump, always putting us down in the presence of the guys! Of course, the basketball players would scream in laughter about her replemanding and reminding us of the reason and purpose for us being there. We stood there looking like little whipped puppy dogs! Evenually the coaches would tell the teams to "pipe down!"

Soon we caught on to what she was really doing! She was trying to make us the best at everything we strived to do. So we found out that Mrs. Stump wasn't as bad as she appeared to be. We all soon grew to love and respect her, who we once thought was a grumpy and mean old lady! We were soon measured for our uniforms. Since I was still wearing a children's size 14, I had to get a size 3. My body was smooth and flawless with a hint of cocoa brown sheen. I was proud of how I was beginning to curve in the right places, however, my breast were much too small. So when we cheered or marched in parades, we would stuff our bras with bobby socks. That would solve the problem! It was an innocent act and we looked absolutely fabulous!

One thing that I did notice was, that my parents never came to see me cheer at the games or march in

any of the parades. They never were involved in the band boosters, PTA (parent, teacher association), or attend any meetings that pertained to our schooling. I usually had to catch the bus or thumb a ride with a friend and their parents. This truly hurt and bothered me. However, this did not stop me from doing my best, it only made me work harder and be more determined to move on and bring change to my life! Today, I see many of the students and chidren using what I went through as an accuse at why they don't succeed and do poorly in school or with their lives. They are playing the "blame game" and having their own "pity party." Society and the government have fed into this and have incorporated all types of assitance and many other programs such as welfare, Wic, food stamps, oil vouchers and Independence cards, to try to alleviate their conscious! This is contributing to "poverty," causing people of lower class to have no self-confidence which continues to promote helplessness and living poorer than their couneter-partners. This poverty is contributed once again to children role-modeling their parents. But as a Black woman, I am here to say that I came from the same background and origin as most of the people who accept being poor and living in poverty as a crutch. This enables them to continue in this vicious "learned en-

vironment." I would like to tell our youth of today to "jump start your lives and move on to higher heights! Parents I say to you, we basically were raised the "right way" so it is up to you to continue to raise your children the "right way!" Help your children set goals and make correct choices! Have your children strive for high expectations in whatever they strive to do! Working with a child is not an easy job, but it can be a rewarding one, if we teach, talk, and lay down specific ground rules that our children should abide by, then things in life will be a much better place for them. I was once told by my Memaw, that it is called "tough love." I have found that too many parents want to be their children's friend. You are not their friend, so parents shape up and do your job! As a mother of two fine young ladies, they will tell you it was not easy living with me, but through it all, they learned to do what was right, to survive and make good choices, have careers, and to be respectable citizens, who are able to take care of themselves! Thanks be to God! And now they are truly my best friends!

One of my principals told me after an evaluation, that my rapport with students was excellent! He said he did not know if it was my many years of teaching, but my high expectations for every student was evident! The evidence was in how each student re-

sponded to me when addressed and how I made them feel they all had a sence of worth. His last statement touched home for me, when it was stated or maybe it is because of your African American background and how I was brought up! I was truly touched by that comment and told him, if I could make a difference in one child's life, all my years of teaching would not been in vain! One of my aunts looked at me one day and stated, some teachers are book learned and others are "born" teachers and you are definitely a "born" teacher! My aunt is a wise woman. It is said to let wisdom be your sister and understanding your closest kin!

Train up a child in the way he should go,
And when he is old he will not depart from it.
- Proverbs: 22:6

Even though my parents were not physically involved with my education, I still had the determination to do my best in school. I still wanted them to be proud of me! I keep making the statement "to make them proud of me," which I know goes beyond my feelings, but to my mother who never pursued her carreer as a teacher. As an adult now, I realize it was not my fault that I was conceived so early in her life. I've learned the choices that we make are our own

and if we do not make wise choices then we end up in destruction! This is something I have prayed about for many years and God has directed me by being my source of strength, understanding, wisdom, knowledge, and love.

Hear, my children, the instruction of a father, And give attention to know understanding; For I give you good doctrine: Do not forsake my law. When I was my father's son, Tender and the only one in the sight of my mother, He also taught me, and said to me: "Let your heart retain my words; Keep my commands, and live. Get wisdom! Get understanding! Do not forget, nor turn away from the words of my mouth.
- Proverbs: 4: 1-6

As I grew into my teen-aged years, I continued to pray and trust in God with all my heart and soul. God was first and foremost in my life! I can remember recieving, during Bible School, my first testament. I was absolutely thrilled. I remember reading it each night and the words were so comforting to me. I gave my life at early age to God and promised to always try to keep his words and commandments! Whenever, my parents began to argue or fight, I would began to pray and read my testament! Even though it didn't

stop them, it did bring peace and comfort to me.

The school year went by swiftly, as did the next few years. The summer when I was fifteen my cousin and I decided to spend it with my grandparents. We had actually planned to get our worker's permits and work at the canning factory with Clara. Since the doctor told my mother it would not be wise for me to return working in the fields, due to the hot sun and the migrain headaches I had started to develop. Diamond was unable to obtain a worker's permit, so she worked in our aunts' beauty salon as a shampoo girl. Things were going extremely well that summer. Diamond and I were thrilled about making money and saving back for our school clothes and supplies.

One evening as we lay in bed talking about some things that we were going to order from the Sears catalog for school, we suddenly heard a screeching of tires as a car stopped in front of our grandparents' house. Since it was so hot and at that time we had neither a fan or air conditioning, we had our window up and the curtains pulled back, and over the window was a piece of screen nailed. Within a few minutes of the car stopping, we heard loud voices coming toward the front porch, which was opened framed with no screen, door or lock. Several white boys jumped on the porch and came directly to our bedroom window, they

were so close we could smell their alcoholed breathes. We lay there with only a sheet over us, with baby doll pajamas on. They peered through the window at us shouting all sorts of obcenities and derogatory comments! These comments soon changed to them making sexual advances, threats of raping us, and other racial slurs! Of course, Diamomd and I were scared to death! We were so horrified we couldn't move or hardly breathe, laying there as two statues! At that time the noise awakened my grandfather, who immediately grabbed his old shot gun and shouted out for them to leave! We immediately jumped out of bed and scampered to our grandmother, once near her we felt safe for only a few moments! The white boys who out numbered my grandfather, shouted back at him "saying old man, we are going kill you and burn all of you up the house!" I was petrified because my grandparents did not have a secure lock on their front or back doors, only a wooden latch fastened by a penny nail. We begn to cry and pray to God that he would send someone to help us! In a split second there was a shot gun SHOT that seemed to pierce the air and I heard our uncle Albert shout the next shot will hit one of you! They ran to their car, screeching away, throwing beer bottles at the house and again shouting racial slurs!

Afterward, we fell on our knees crying, sobbing, and repeating the Lord's prayer! We never slept with our windows open or the curtains pulled back again, no matter how hot it was. We decided we would rather sweat to death, then to be scarced to death! Once again segregation had "reared its ugly head" letting us know as blacks, stay in your places and always beware of your surroundings.

Do not fret because of evildoers, Nor be envious of the
wicked; For there will be no prospect for the evil man;
The lamp of the wicked will be put out.
- Proverbs: 24:19-20

Blacks tend to be very religious people and great believers in God due to the fact that we feel He has brought us through many trials, tribulations and a mighty long way! This stems back to our ancestors, who were slaves. They felt God was with them each and everyday while in the cotton fields, when they would feel the sting of the whip or following the underground railroad to freedom in the North. With the many tramatic experiences that we encountered growing up, it is a wonder that we made it as far as we did!
Who has woe? Who has sorrow? Who has contentions?
Who has complaints? Who has wounds without cause?

50

Who has redness of eyes? Those who linger long at the wine, Those who go in search of mixed wine. Do not look on the wine when it is red, When sparkled in the cup, When swirls around smoothly; At the last it bites like a serpent, And stings like a viper. Your eyes will see strange things, And your heart will utter perverse things. Yes, you will be like one who lies down in the midst of the sea, Or like one who lies at the top of the mast, saying: "They have struck me , but I was not hurt; They have beaten me, but I did not feel it. When shall I awake, that I may seek another drink?"
- Proverbs: 23:29-35

As my teen years went on and I grew into adulthood, I learned to separate my mind from sin and keep my eyes on the Lord, in order, to be able to rejoice in him and say: "Behold the Lamb of God!" From my youth I learned if you abide in Christ you will surely grow! "God has spoken once, twice I have heard this: That power belongs to God!" What will happen next?

*You therefore, beloved, since you know this beforehand,
beware lest you also fall from your own steadfastness,
being led away with the error of the wicked: but grow
in the grace and knowledge of our Lord and Savior Jesus
Christ. To Him be the glory both now and forever more.*

Amen

- 2 Peter: 3:17-18

Part Two

Even though more than three decades have elasped, I continue to teach and nuture students in many capacities; that of a classroom teacher in the public school system...a Sunday school teacher... a correctional education teacher! The memories of working with these students: young children, adolesants, teen-agers and adults still flood my mine...as waves in an ocean on a balmy spring day in May! All of my teaching experiences have been very rewarding! I have watched all my students grow academically, in wisdom and maturity! However, teaching in a prison with several hundreds of inmates has touched a special place in my heart. Many of my former students from the public school system now reside as inmates! When talking with them, my only response to them is to, look to God for your strength and salvation and to God be the glory! One inmate that was elderly told the younger inmates one day in class, "a mind is a terrible thing to waste!" He came to that realization after being incarcerated for many years! I went to work one day to find out he died that evening! I, indeed was crushed and I prayed that he had time to ask God for forgiveness! So now, I feel not just as a teacher, but a parent, a warden, a correctional officier and even from time to time a preacher! Ministering and spreading the word from one person to another.

I informed them that they needed to prepare themselves by following the commandments that God has set for us, in order, to be able to enter the kingdom of heaven.

The preparations of the heart belong to man,
But the answer of the tongue is from the Lord.
- Proverbs: 16:1

LET'S STOP AND REFLECT...

I allow my mind to drift back to a time of leaving the safe environment of my small town as a country girl. My life before going to the big city to college was one that most blacks can vividly identify with if they lived during the 1950's and 60's. Born in a rural setting plagued with prejudism of being black in a white man's world was very natural and acceptable during that time period.

My parents were hard-working and did not have a lot of money. However, we still managed to have the things that were needed. My dad worked at many jobs during his life time. I can remember him working in the timber woods, driving a large timber truck loaded with logs. The smell of the pine trees on his clothing when he came home still penetrates my nos-

trils. He was a good man! My mom, also, worked hard at many odd jobs as we grew up. She was a beautiful woman, since she did have Cherokee Indian in her blood. My mom made sure we had the best, but did not mind causing havoc with my dad! I feel some of this hostility was due to the fact that she had to give up her dream of become a teacher and marry since she became pregnant. Nevertheless, she worked hard cleaning the homes of the whites, ironing clothes, even working in factories.

My mother's mother, Memaw, was the love of my life. She blessed her daughters with her radiant beauty. Although she was very quiet and mystical , she cared for her children, grandchildren, and any other child that would make her aquaintance. My mother always taught us to be polite, kind, and courteous to everyone, especially our elders. She, always, wanted me to become the teacher she never was! It was almost as though she was grooming me for the position. Thus, in school I always did my best to get good grades, in order, to get a scholarship to go to college. Without a scholarship, I am sure I would not have been able to attend college. Therefore, I had to maintain my grades. I loved all my teachers and they loved me, since I listened, made no trouble and followed directions.

When wisdom enters your heart, And knowlegde is pleasant to your soul, Discretion will preserve you; Understanding will keep you, To deliver you from the way of evil.
– Proverbs: 2:10–12

Even though my mother wanted me to be a teacher, my deep dark perference was to be a nurse! We both knew I wanted to be a nurse, since I had already sent in my application to nursing school at the UMCP. Mom a typical black woman felt that if I did become a nurse and worked different shifts, when I married my husband would not be there to care for our children properly. Not knowing anything about marriage, husbands or having children, I listened to her and became a teacher!

As I graduated from high school and journeyed away from home to college to pursue my career in the field of education, deep in my heart I felt I was ready to take my stand in life and diligently seek my place in society. My mother made sure that I was well-groomed, well-dressed and classy looking! My aunt was a beautician and she gave me a beautiful cut hair style, after dying it "penny red." She taught me to arch my eyebrows , to put on just the right amount of make-up showing a flawless look. My clothes ac-

cented my tiny figure. Each oufit my mother bought me, was matched with shoes and bags. Several cashmere sweaters and leather coats completed my wardrobe. No one would ever guess I came from a family who worked and scrambled for every penny they made, in order, to survive. No one even knew I was from the country until I opened my mouth and they heard what they called "a southern drawl." Which my new found friends called the "Eastern Shore lingo." It caused us all to laugh, especially me because the guys said it made me look even cuter than what I was! I worked hard getting rid of that drawl as I went through college. I would listen to my teachers, my new friends from New York , D.C., Indiana and other parts of the country and I even took a few speech classes, until finally I had a new lingo!

Does not wisdom cry out, And understanding lift up her voice? She takes her stand on the top of the high hill, Beside the way where the paths meet.
- Proverbs: 8:1-2

College came easy for me, since in high school, I developed excellent study skills and time management. When I finally completed the required credits that were mandatory for new college entrants, I was

ecstatic to start my core area of study for my major, education. The courses were so interesting that I felt like I was on a natural high during lectures, writing essays, having labs and even preparing for exams. Each class, each seminar, each method class, and each day brought something new for me to learn. It was transforming and molding me into the image in which I would perform...that of a TEACHER!

Little time was left for parties and other out-ings, however, I did manage to squeeze in a little free time in for enjoyment. Which was absolutely a wild time for me, since at home we seldom were allowed to go ANYWHERE! So I would spread my wings and party down, when time permitted! Evenually, I did start working on a work study program to earn extra money for needed items. My parents and aunts would send me money from time to time. But money during that time came hard and they barely made enough to pay for the necessities in their own lives. I worked for the atheletic department, typing and filing. It was a great experience for me. From time to time I was invited to go to some of the athletic functions on and off campus. I would invite a few friends and we would dress to impress and enjoy the outing! Working in the athletic department opened my way to become a cheerleader for the football team, which

I dearly loved, since I did cheer in high school. The road games were truly exciting, because I got to travel to places, I had only dreamed to see!

I was finally ready to do my student teaching! Wow, this was such an exciting time! Even before starting, my critic teacher met with me during my observation courses and told me she felt I was "born to teach." It was as if I had a thirst to work with students, watching them succeed and striving to reach their potential. My first experience of student teaching was in the inner city. A little nervous and apprehensive, I still stayed focused as I started this journey. I prayed to God that he would give me the strength to endure what was ahead of me. Once again I thought: what in the world is next?

Hear my cry, O God; Attend to my prayer. From the end of the earth I will cry to You, When my heart is overwhelmed; Lead me to the rock that is higher than I.
- Psalm: 61:1-2

My philosophy of teaching was to "be firm, fair, and focused!" I must say after observing Mrs. Blair in action as a teacher, I knew that if I followed her steps as a teacher, I would in deed become a "master teacher." When arriving, at my teaching experi-

ence, I must say I was shocked to see the thirty-two students staring wide-eyed at me. Their expressions said "gotcha!" Brushing that thought away, I mentally said, how sweet these little creatrures were. On the contrary, to say in the next few weeks, I found out they were the "kids from hell!" Since I had no car at that time, I had to catch a transit bus from campus to my scheduled school. Much to my surprise, the ride that early in the morning was a sober one. There was none of the usual roughness of shoving, pushing, standing, being leaned on, cursing, smelly bodies, or hateful stares! Normally, I would have an hour bus ride to endure the belittling atmosphere of riding the transit "rollercoaster."

When stepping off the bus at my scheduled stop, I was welcomed by many little feet whizzing by me at an unsafe and unacceptable pace. Nevertheless, all seemed well and happy. As I walked toward the school downed in my brown plaid-pleated skirt suit, matched with a tan turtle neck and a suede jacket, little spool-heeled shoes, with matching bag and book satchell, I was happy. I did, I must say, look very professional. I was on cloud nine on my way to my first student teaching position. Many good mornings, smiling faces, eager to get to know you looks, some sly and mischeivous coming especially from the boys.

My stomach was in a ball of knots as I walked into the classroom. Mrs. Blair had an area in the classroom set aside for me . The balloons that adorned my desk, along with the flowers gave me a welcoming feeling! After greeting the students at the doorway, Mrs. Blair gave me my first assignment, calling the attendance. This was a major catastrophe...calling and mispronounciating of the names, brought many whooping and screaming with laughter from the students. Many of these names I had never encountered or even heard of before, so of course I was grasping at straws with saying the names correctly. I stopped took a deep breath and started again. So , I learned a valuable lesson, always when in doubt of how to pronounce a name be honest and say could you please say your name for me! I caught on real fast and was able in a week to pronouce their names and match the names with each student. Battle one was over but there were many more skirmishes to occur!

Behold, the children are a heritage from the Lord. The fruit of the womb is a reward. Like arrows in the hand of a warrior, So are the children of one's youth.
- Psalm: 127:3-4

The excitement of student teaching was still to be seen as well as heard. As the days turned into weeks, the excitement and love of teaching became such an enjoyable task, that I spent every waking moment preparing lesson plans and thinking up stratedgies to make those lessons more creative and interesting for the students! The highlight of my day was to watch the progression of each student reaching their full potential. One example of my creative thinking was setting up a store in the math center, in order, for them to count money and learn how to make change. The students truly enjoyed going to the store and making purchases, counting money and giving back the correct change. Each day during the unit on money, we would have a different cashier. There were times some students did not have money, so I saved all my change and brought it to school to stock the store and give the students without money some change to spend. I guess you are wondering where a poor college student got this money to use for this project. Well, as I stated earlier, I had a job on campus working on a Work Study program to earn extra money. Also, from time to time, I would help tutor students in the library. So of course, it was a pleasure and honor to be able to help these students in any way possible to succeed and start on their road as productive citizens.

The days of my first experience drifted on, it seemed the calm before the storm or woman's intuition, but I had mentined to Mrs. Blair that I had a feeling that something was going to happen. She informed me that it was only nervousness due to my first student teaching experience. That I should not worry and be more confident in myself. My confidence level seemed to soar! As my student teaching was coming to an end, the "boil" came to a head! As a culminating acticity, I gave the class an honor's program/ party. This program was an incentive for them being such great troopers doing my stay at the school. I was so pleased with the progress I had made during this time period and that Mrs. Blair gave me such a raving report on my success, I invited my supervisor from college, the supervisor of education, the principal and the students' parents. This to me was a big deal! After a brief program, I gave out pencils and ribbons to the students. Needless to say, you always have one student who is going to be rebellous or just wants to be seen. This boy decided he did not like the color of his pencil, so he snatched a pencil from another student. She began to scream about her pencil. I immediately walked over and took the pencil back from the student and gave it to the girl. The boy looked at me, he kicked me and ran out of the room

screaming and yelling "you poked me with the pencil." My first thought how, it wasn't even sharpened, thank God! Mrs. Blair and the principal came to my rescue! The little boy came back into the room apologized to me , the students, and our guest. As I look back on this episode, I think, I could I have handled it differently? I prayed to God that night that I would beable to handle my relationship with this student with love and understanding for the next few days!

He who gets wisdom loves his own soul;
He who keeps understanding will find good.
- Proverbs: 19:8

As I ventured into my second experience, I took with me a valuable lesson: wisdom and understanding. A lot of the things we learned in our method classes before student teahcing proved to be invaluable. I quickly learned, experience is the best teacher! My second experience was in an elite section of the surburban area of the city, which was predominantly white. The students there had parents that were doctors, lawyers, college professors and other high ranking CEOs. The students were also high ranking academically and very well-behaved in all aspects of the word...discipline! Of course since it was a middle

school, and departmentalized, I was the new science instructor. The first unit of study was Biology, the science of life. I must say we all learned a lot, even me! I had to work as hard as the students, every minute, in order, to keep up with my accelerated classes. I was pleased with myself and my critic teacher was appauled at the many excellent projects that I introduced to the students to go along with their unit of studies. The highlight of the experience were the parents. They were always willing to volunteer, assist, and even be reasources as guest speakers. One father was a heart specialist, so when we finsihed the circulatory system unit, he came in bag and baggage with a wealth of information to share and pass out to them. I could never have realized the many presentations that were offered by these parents. Did I learn a lot during this second experience, more than you would ever imagine! All I could think of was...What in the world is next?

Do not boast about tommorrow, For you do not know what each day may bring forth. Let another man praise your own mouth; A stranger, and not your own lips.
- Proverbs 27:1-2

Life in college had been an overwhelming, challenging, and rewarding experience. I thanked God each and every night and day for bringing me thus far. A country girl had gotten the "ride" of her life! Not all of my life centered around academics and studying while in college. I had become quiet a socialite. I enjoyed partying, football games, cheerleading, splash parties ... wearing those skimpy bikinis, which showed off my beautiful curves and the many rush parties that were given by the different sororities. So naturally, I pledged and became an AKA (Alpha Kappa Alpha), which was one of the first black sororities to be instituted.

Upon graduating, I was like a vulture preparing to escape into an unknown world, not knowing what was lying ahead to prey upon me! I knew that with God's help, I would have the strength to conquer whatever lay ahead of me. I know God knows best and I know, too, that nothing comes to us that has not passed through him. Keeping this in mind and staying focused on God, I knew I could leave college and become the best teacher ever! I felt blessed and grateful that I was now ready to enter the work force and educate all who desired to learn. Through God's help I had fulfilled my mother's dream...a TEACHER!

My graduation was simply awesome! For our cer-

emony the keynote guest speaker, was the Rev. Jesse Jackson. At the end of his heart-wretching, emotional, and self-teaching speech, he asked the graduating class of 1972 to please stand. Rev. Jesse Jackson started reciting the famous speech, "I Am Somebody!" by Rev. William H. Borders, Sr. As he recited the verses we all would chant out "I am Somebody!" At that moment I knew then, that "I Truly was Somebody!" And I owed it all to God Almighty! To him I give the glory!!!

I Am Somebody

I Am Somebody
I Am Somebody
I may be Poor, But I Am Somebody
I may be Young , But I Am Somebody
I may be on Welfare, But I Am Somebody
I may be Small, But I Am Somebody
I may make a mistake, But I Am Somebody
My clothes may be Different
My face is Different
But I Am Somebody
I Am Black, Brown, White
I speak a Different Language
But I must be Respected
Protected
Never rejected
I Am God's Child
I Am Somebody!!!!

by Reverend William H. Borders

"Glory to God in the highest.
And on earth peace, goodwill toward men!"
– Luke 2:14

Saying farewell to all of my friends and professors, left a bittersweet taste in my mouth. As much as I hated to admit it, I would miss my new found family of the past four years! As I glanced around the campus for one last time, all I could think of was what a great experience I had endured, but where had the four years gone! My entire family attended my graduation ceremony, however, there was a void, a gaping whole in my heart...my brother, who was a year younger than I, had been killed during my sophmore year. He was home on leave from the army awaiting to be deployed to Vietnam, when he was in an automobile accident. I really missed him and I whispered to him a memorable prayer and closed by saying I know you are here with me and the family and that you too are proud of my accomplishments.

As we pulled away from the campus, I remember peeking back over my shoulder taking one last look at my college campus. I saw in the distant sky beyond the campus steeple a bright light stretching across the sky and at moment I knew that God was telling, me, you have crossed another hurdle in your life, continue to believe and trust in Me and yourself and you can do all things! For only through the grace of God did my "dream" come true. With a lot of hard work and trusting in the Lord did I reach my goal in life. I

can remember Memaw saying, when one door closes another one will open. Thanks be to God that it was made possible, that I was able to walk through that new opened door.

Strength and honor are her clothing;
She shall rejoice in time to come.
- Proverbs: 31:25

Part Three

College prepared me for the many obstacles that I would have to embark upon and endure in this world of becoming an adult. Doing my teen years, I was given the neccessary skills and work ethics, from my family members, that I needed, in order, to become successful in the working world. As an adult with a college degree in the field of teaching and being the ripe-age of twenty-one, I felt I could conquer the world! Instilled in me were God's words: "Take My yoke upon you and learn from Me, for I am gentle and lowly in heart, and you will find rest for your souls. For My yoke is easy and My burden is light." (Matthew 11:29-30) Those words gave me the strength to press onward to higher heights. These words helped feed my soul and gave me a sense of worth to continue my journey that was set forth for me.

As the days flooded before me one into another, I could feel the sensation of living my life as a teacher, who would inspire and take students on many adventurous journeys through that of education. I wanted to teach and make a difference in the life of each child that I would come into contact with... this was my main focus as a teacher! However, at times we all need to stop, reflect and re-evaluate our lives and consider at what point did we want or did we decide

what we wanted to be "when we grew up." Also, think at what time did our childhood fantacies of becoming a doctor, nurse, lawyer, NFL player, firemen, truck driver, preacher, teacher or any other professional related career direct the path we would take to become the person we are today? Immediately in my mind there again was that question: What in the world is next?

Brethen, I do not count myself to have apprehended; but one thing I do, forgetting those things which are behind and reaching toward those things which are ahead. I press toward the goal for the prize of the upward call of God in Christ Jesus.
- Philippians 3:13-14

As I look back over my life, I can think of numerous people who helped define my life and caused me to become the person I am today. It may have been a favorite teacher, a family member, someone in the community, the minister or a famous star from televison who captured my attention and held my interest and became that role-model who aspired me to be the person I am today! My mother, regardless of her hard and strict ways at times, is the first and foremost person who wanted and beleived in me to

make a difference in my life of becoming a teacher. She did instill in me some life-long values and work ethics that would lead me through a life filled with following the correct path. She had a dream that she did not fullfill, that of becoming a teacher. Therefore, I felt almost obligated to become that person she had always wanted to be and was unable to become due to certain circumstances. I can truly now say, "Mom, I did this for you and I hope I was the best teacher in the world, just for you!" There were many excellent teachers who influenced my desire and choice to become an educator. They all were outstanding and well-versed in their profession. Two in particular inspired me and made it clear that a teacher was the right choice. My cousin, I will call her "Sweetie" and my second grade teacher, Mrs. Beasley. These two teachers always went the extra mile for their students. They were once again more then teachers, they were mothers, counselors, mentors, role-models and friends to their students. This was a gigantic package to fill, but they were successful in accomplishing it and filling that empty void in the lives of hundreds of students. Mrs. Beasley seemed to love and truly believe in all of us. She had a certain chemistry with all students that seemed to radiate throughout the classroom each and every day. There she would stand in the front of the

classroom, well dressed, every hair in place, with an angelic smile, well-versed even when she would say "Good morning," the sound sent sparks through your body. This I thought was how I wanted my life to be! Watching and observing her every move instilled in me a state of urgency and strife to become the best at whatever I strived to do!

"Strive to enter through the narrower gate, for many, I say to you, will seek to enter and will not be able to."
– Luke 13:24

Returning home after graduation, I knew I had to remember all who had inspired me to finish my education and had been excellent role-models in my life to become the best teacher that God had empowered in me to be! Staying focused on my teaching career was my main goal. I had no idea that I would stay home and make it my destination to ensue my life as a teacher. However, as we all know God has our life already planned-out! Therefore, it was not in His plan that I return to the city to teach, but to stay at home to nuture, teach and touch the lives of the many children in my community. So I stopped to think and thank God for what he granted me to do with my life; not to waddle or fret in self-pity, but

to once again re-evaluate my life and say a humble prayer of thankfulness to my God. I knew at that moment God needed me to stay home, to become involved in the lives of the numerous children here and to make a difference in their lives. Also, to let them know even with the background and status of our lives, we can have the career of our choice as long as we make the right choices. Since I had grown up in this area and was poor and often times stricken with poverty, I could identify whole-heartedly with them. It does not matter where you come from or what monetary things you may or may not posess, you can still have a career and become whatever or whomever you so chose to become! It's all about the choices we make! Always stop, reflect and think, and even ask this question from time to time, what in the world is next?

Give her of the fruit of her hands,
And let her own works praise her in the gates.
- Proverbs: 31: 30

I immediately went to a neighboring county and applied for a teaching position. As I walked into the Board of Education building, wearing shorts, a tank top and flip flops, I told the secretary in human re-

sources that I would like an application for a teaching position. As we conversed a gentleman over heard our conversation and came over to introduce himself. He informed me that he was the superintendent of the county, Mr. Fuller. I was truly taken aback because of my attire that I was wearing. This outfit was something you would not normally wear to an interview! I can remember the first thing that we were taught, at all times, dress to impress. But it wasn't suppose to be an interview? He politely asked me if I would like to take a ride with him to a neighboring school; a little puzzled, I answered yes. We drove to a beautiful section of the town, where we proceded to enter an elementary school. As he escorted me in, we walked along the corridor to the end of the hallway, he opened the door to a classroom. As I walked in he immediately asked, would you like to be the instructor of this classroom? I almost fainted and felt a little woozy, but all I could muster out was a meek "yes." All I could think of was, what are chances of me getting a job I was dressed so inappropiately? All I could think of was... What in the world is next?

I would have lost heart, unless I had believed, That I would see the goodness of the Lord, In the land of the living.
- Psalm 27:13

Well, I got the job! I was officially an elementary teacher of a first grade class! Reality had just set in and thoughts of my life flooded through my mind. What an adventurous trip I had taken in my life to get to this point! I had faced so many barriers and obstacles which made me stronger than I ever thought possible. I remember my Memaw saying quite often to us: "only the strong survive." I had never before thought of myself as being strong, but I guess I was, I had survived a journey and reaped the benefits that most of us would find unheard of coming from my "circle of life." God had opened another door for me to enter. As I embraced all the power that God had given me, I began to step out on faith and transform my new life. I knew that with the knowledge I had obtained through growing up in a rural setting in the 50's and 60's, going to public schools and working to become an honor student, in order, to qualify for a scholarship to enter college, and facing the challenges with going to college in a big city; I would have the power to become a master teacher! With this new found power that God had granted me, I knew I could bring the education and nuturing needed for students to become successful. With this empowerment as well as my passion, wisdom and understanding of all I had encountered in my life, I knew I was ready to start this next chapter of my life.

For wisdom is a defense as money is a defense,
But the excellence of knowledge is that wisdom
gives life to those who have it.
- Ecclesiastes 7:12

The years seemed to "fly by." I thoroughly enjoyed the time I spent with the students and staff. The students were all so very different and each day presented many new challenges. Therefore, with these different personalities and learning modalities I had to develop a plan of action that would fit each students' needs. This was not a simple task! With the presentation of the needed skills and goals, I had to administer and attack every avenue of teaching to make sure they were successful. I always strived to make the lessons and activities come "alive!" I felt if they could read, write, do arithmetic, and have the basic skills, they could accomplish any given task. So through lesson planning both short and long range, setting goals for each after administering the neccessary tests, implementing the scope and sequence for all materials needed in the curriculum, modeling of lessons and skills, and giving the nuturing needed to each child would help them become highly-motivated and successful in school.

My stay at this elementary school was greater

then I ever could have imagined. I always received raving and superior ratings from my supervisors, principal and vice-principal. I credited all of my success as an outstanding teacher to these observations by my superiors and more experienced colleagues. These teachers were masters and would make sure we were always knowledgable of the teaching experience. From planning of lessons to making sure each student received as much nuturing as needed. These teachers were excellent role-models who instilled in us to strive for the best and except nothing less then the best!

Therefore, my philosophy as a teacher became the three F's: to be firm, fair and focused at all times on the needs of the students. I must say all of the students I taught always seemed to excel. Some might say, "why are your students so successful?" I would always say put the education of the student first. Always set and follow the goals for each child. They are individuals and they all learn differently and not at the same rate, so you have to be willing to do that individualized teaching plan on their level of needs. Teaching is not an easy job, but it is a rewarding and a fulfilling one, especially when seeing the growth of the childern. This is an emotional and almost magical feeling to see the accomplishments that will happen

as you transform and mold these minds academically!

I decided to further my carreer and return to school to pursue my masters degree in education. I enrolled at a neighboring college at night. In completion of receiving my masters degree, I, also, was honored a "master teacher!" This was such an honor to have this title linked to you as a teacher. That same year, I was selected for Teacher of the Year from my school. Even though, I didn't win at the state level, I felt happy to have been considered by my collegues, students, parents and the administration. All I could think of was: What in the world is next?

For God gives wisdom and knowledge
and joy to a man who is good in His sight.
- Ecclesiastes 2: 26

My life once again took another turn, I got married. This to me was another mile stone and accomplishment. I was both thrilled and joyful that God had put this man in my life. My husband was a hard-working man. I guess one would call him a workaholic! He wanted and liked nice things and so did I, so we both made some dreams come true. My last inital of my name did not change. Since my maiden name was at times hard for them to pronouce, I allowed them to call me Miss M. So when

I returned the following school year, I became Mrs. M. The students found humor in the new opener of my name. Children are happy "little people" who in turn make adults happy "big people!" They seem to light up our lives. A secular song always comes to my mind when I think of children: "You light up my life." Life for the next few years continued to be fulfilling, deserving and meaningful. Even though I was married, my job as a teacher did not change. I spent hours pouring over my lesson plans, always thinking of ways to make them more creative. My husband stated to some friends once, "--- is a teacher from September until June, don't bother her during that time frame." I did feel a little guilty and tried to bend a little to have some down time. The parent support in the school was phenomenal! You had only to ask and you would receive. The adminstration was, also, awesome. During the planning of my wedding they wanted to help in any way possible. So putting all of these wonderful people together along with "me" and you have what we nicknamed our school, "God's country!"

"Yes, you yourselves know that these hands have provided for my neccessities, and for those who were with me.
- Acts 20: 34

Even though, I had married and had a great job with my students and new found friends on my staff; there was still something missing! Don't get me wrong, I was so very thankful to God for all he had provided for me! However, I had this burning desire to have a baby of my own. I had been teaching for several years and felt I was ready for children. My husband and I decided it was indeed time! I tried for several months to conceive and but I did not have the pleasure of becoming pregnant and a mother. So, I immediately sought help from my gynecologist. He started me on a regiment of procedures to follow, to try and become pregnant. I charted my temperature to find out the day of ovulation, tried intercourse on the 14th and 16th day of my cycle, had my womb tilted and even took futility drugs. Nothing worked! I started blaming my husband for working too much and missing my days of ovulation! I think back now, I had been so childish, immature and a little silly! I finally said, enough! I talked to my minister and she told me to pray about it and leave it alone, if it was God's will, I would have a child. I did and guess what? I became pregnant! During the next few years I was blessed with two beautiful daughters. I felt now my life was complete! God had granted my life with two wonderful blessings. I was so thrilled with them,

it was beyond what words could express. I did learn something, I thought I was a great teacher, however, after having children, I felt I was magnificent! My patience and tolerance level soared to a height that was unbelievable due to me now having my own children and developing that new sense of motherhood. I thanked God for loaning me these precious gifts. I liked this new feeling! As a teacher I was even more giving, nurturing and understanding. As an individual I became more patient and christ-like! Thanks be to God for all the rich blessings he had restored upon me.

Then He arose and rebuked the wind,
and said to the sea, "Peace be still!"
And the wind ceased and there was a great calm.
- Mark 4: 39

Satan has a way to rear his ugliness and venture into our lives when we least expect it. These unpredictable times and appearances of Satan sometimes bring a feeling of defeat. But then we have to pray and continue to believe that God will intervene and once again we will be drawn near to him and he will cleanse our hands and purify our hearts from sin. My oldest daughter on her fourth birthday was stricken with a deadly illness one Easter Sunday morning! I

can remember awakening that day and seeing almost a halo of joy surrounding her! We attended the Easter service where the children were in charge of the program. I was in charge of the children at church during Sunday school, Bible school and any of their programs. It was if children would be forever a part of my life. And I thanked God for being surrounded by them everyday of my life. My oldest daughter stepped in front of the altar and recited her recitation so vibrantly and with such distinction. She had such an angelic smile as she finished and bowed to the audience. Afterward she lay her head upon my aunts shoulder and fell into a deep sleep. This was very odd for her to do. We did get to wake her momentarily to get into the car. Upon arriving at her favorite place to eat, McDonalds and offering her favorite food, "french fries," she refused them and went back to sleep. Again this was very odd, because she always wanted fries. Early Easter Monday morning, when I went to check on her, she lie there in a rigid fetal position unable to move. At first I let out a silent scream! Then I arouse my husband and called my aunt to relay what I had seen. My aunt immediately came to my house and off we went to our neighboring local hospital. Once there the pedertrician examined her and told us it could be a hundred different things, but

they were not equipped to handle it, so they were fly-ing her to a big city hospital that specialized in chil-dren's diseases! Fright took over all my sense of being. All I could was fall on my knees, with out-stretched arms and think of Psalms 9:9-10.

The Lord also will be a refuge for the oppressed,
A refuge in times of trouble. And those who know Your
name will put their trust in You; For You, LORD, have
not forsaken those who seek You.
- Psalms 9:9-10

Upon our arrival at the city hospital, two neu-ro-surgeons were waiting for us to discuss my daugh-ter's illness and they gave us the prognosis of what they had found. The doctors informed me that she had been stricken with what they thought was triple E eastern equan encephalitus, which was a disease where fluid has built up around the brain and that it could be deadly. This time fear of losing her set in and again I closed my eyes and thanked God for letting me have enjoyed this precious gift he had bestowed upon me! Once I opened my eyes and caught my breath they stated it could have been contracted from a mosquito. However, there were no puncture wounds on her body, so they said it could have come from a

simple ear infection which was not treated correctly. Again a puzzling look befell my face, since I had always taken both of my children for check-ups and their shots were all up to date! The surgeon stated that sometimes doctors gave the same antibiotic too often and the children can build up an ammunity to it which causes them to be unable to fight off diseases. With that answer from the doctors, all I could think of was; What in the world is next?

In the day when I cried out, You answered me, And made me bold with strength in my soul.
- Psalm 138:3

We were given several options of how her illness could be treated. Since they were not 100% sure of the diagnosis, they said they could give her medication through an I.V. and play the waiting game to see if it worked or they could take a biopsy from her brain to be certain! My husband and I and even family members were all so baffled that we did not know what to say or do! The doctors gave us a few hours to discuss it and make a decision which was so very hard. When he returned we still had not made a decision. After much prayer and going back and forth with conversation, I flat out asked the doctor what

would you do if it were your child? He told us he did not want to speak for us, however, if it were his child he would want to be certain of the virus and do the biopsy. I thanked him and signed permission for him to operate!

The Lord will guide you continually, And satisfy your soul in drought, And strengthen your bones;
You shall be like a watered garden, And like a spring of water, whose waters do not fail.
- Isisah 58:11

The surgery was successful, she did have the virus the doctors said she had contracted. As they wheeled her out of the operating room, I can still close my eyes today and see that angelic face, head bandaged into a bow for me, laying there sleeping so peacefully. My heart was breaking into a million pieces, wishing I could take the pain and her place laying there. They informed us she was in a coma and once again it would be a waiting game. Again, I fell on my knees and whispered a prayer of thanksgiving and thanked God that he had brought us this far. I informed my family, friends, collegues, and everyone that had been there for us, in our time of need, that she was going to be alright. God does perform miracles everyday!

I will praise the name of God with a song,
And magnify His with thanksgiving.
– Psalm 69:30

My aunt and I decided that we would stay until my daughter was able to return home with us. Some of the doctors thought we were crazy and said go home, she would be in a vegetated stage or brain dead for the remainder of her life! What a horrible thing to here and say. I remember the words of my aunt, when she told them "Satan flee, we know a Man who is more powerful then we!" It's funny how people look and take you when you answer them with the bible as your sword. They immediately stepped away from these strange people as they from time to time call christians who are armed with the words of God! From that day on her progress began to transform. A tube out, a yawn, blinking eyes, moving limps!!! We continued to talk, read, sing, pray and encourage "the little one" to wake up; and the third week after her surgery she opened her eyes and looked at me with tears streaming down her sweet little cheeks. I grabbed her ever so gently and held her in my arms and the rest of the story is history! She is now a thriving woman and by the way at an early age she stated she wanted to

help people just like they helped her! She is a nurse, working in rehabilitation! All I can think of is: What in the world is next? God is so good!

Praise the Lord! Oh, give thanks to the Lord for He is good! For His mercy endure forever. Who can utter the mighty acts of the Lord? Who can declare all His praise?
- Psalm 106:1-2

Life is good... Thanks be to God. He granted me a second chance as a mother to my oldest daughter. I vowed to him to be the best mother ever! Children do not ask to be born, so as parents we have to bring them into this world and love, nuture, protect and provide for them in the proper way. I felt with this second chance as a parent, I would love, honor and obey God's Word even more. When God grants presents with the gift of becoming a parent, I feel this is one of the greatest gifts and love of all! I prayed for God to grant me the wisdom and strength to endure the power to teach my children the values, ethics and to follow His commandments. In doing this they, too, would be more obedient and Christ like. My daughters continued to mature and grow and be obedient through my mentoring, nuturing and love for them. They work spiritually in following God's

path and commandments, in order, to enter the king-dom of heaven! This was taught to me by my parents and grandparents and in turn I handed it down to my children. I am not saying we are perfect in following what doth sayeth the Lord, but we strive each day to try to do the right things. At times it is a battle, but the battles became smaller skirmishes thanks be to God!

Make me understand Your precepts; So shall I medidate on Your wonderful works. Give me understanding, and I shall observe it with my whole heart. Your hands have made me and fashioned me; Give me understanding, that I may learn Your commandments. You, through Your commandments, make me wiser than my enemies; For they are ever with me. Through Your precepts I get understanding; Therefore I hate every false way. Your work is a lamp to my feet; And a light to my path. I am Your servant; Give me understanding, That I may know Your testimonies.
- Psalm 119:27, 34, 73, 98, 104-105, 125

The years that followed the illness and recuper-ation of my oldest daughter seemed to go by swiftly, just as a tornado that touches down and immediately disappears. Time has a fashion of waiting for no one

and if we are not careful we can get caught up in the worldly things that exist and forget our purpose of being here on earth. Materialistic things are so easy to acquire, however, that love of money and the making of it, is one thing that can bring a division and strife into the lives of us all. In Matthew 6:10, it tells us: "For the love of money is a root of all kinds of evil, for whichsome have strayed from themselves through many sorrows." We forget that we are not to flee from these things that bring us happiness and status, and pursue righteousness, Godliness, faith, love, patience, and gentleness. We tend to get caught up and forget that as man and woman, when we take our vows of marriage we need to nuture the growth of our "oneness!" I often compare this with the watering of our grass during a drought. If we want this marriage to stay green, we need to water it often, if not it will turn brown and die. So without the nuturing and caring for our marriages we will go astray and disregard those vows that we pledged before God! Several years passed by and my marriage ended in divorce. The divorce to me seemed like an end of something that had started as a new beginning. It felt like a death! We think of death as being final! Divorce for me took on all the characteristics that apply to and happen during a death. Webster's dictionary gives several

definitions for death, there are two which I feel describe a divorce. The first one was the "end" and the second one was "destruction!"

> *The Lord is near to those who have a broken heart,*
> *And save such as have a contrite spirit.*
> *Many are the afflictions of the righteous,*
> *But the Lord delivers him out of them all.*
> *- Psalm 34:18-19*

Even though we recite the marriage vows which include "tell death do us part," it does speak of divorce in the bible; Dueteronmy 24:1 and Mark 10: 4. I used these two books to guide my understanding and my interpretation of divorcing. It speaks of God joining us as one flesh and that it is adultery upon the one who obtains the divorce and marries another! However, it, too, speaks of Moses permitting a man to write a certificate of divorce and dismisssing her. Jesus said, it was done because of the hardness of your heart that he wrote you this precept. As humans we strive for understanding of what thus sayeth the Lord. So knowing that God does forgive us of our sins, I feel we are forgiven if we confess to Him with sincerety. Once again, that questions creeps back into my mind: What in the world is next?

If we confess our sins, He is faithful and just to forgive
us our sins and to cleanse us from all unrighteousness.
- 1 John 1:9

Life with my daughters continued to flourish. The days turned into weeks, the weeks into months, several years had gone by. My life with my daughters was beyond compare to anything I had ever experienced. I watched as they turned into beautiful young girls possessing such gracefulness. I compare them with a delicate seed, which was planted and bloomed into a gorgeous rose! They were, indeed, the "apples of my eyes!" They were so good, highly intelligent, well-versed and academically ahead of themselves, which I thanked God for each and every day; these wonderful gifts God had loaned me for a little while. I made sure we at least took one trip each year to let them know and see there were other places out there, then just this small remote area we lived in. I instilled in them that we do not live in this world alone and should be able to get along with everyone, regardless of their race or gender. That statement puts a smile on my face each time I think of it. Every Christmas I would always purchase two dolls each for them: one black and one white, stressing that we are all equal in God's sight and we should always love one another!

If keep my commandments, you will abide in My love,
just as I have kept My Father's commandments and
abide in His love. These things I have spoken to you,
that My joy may remain in you, and that your joy may
be full. This is My commandment that you love
one another as I have loved you.
- John 15:10-12

Years went by and I continued to teach and nuture my daughers as well as my students at school. I stayed focused with my life and trusted in God to empower me with the strength to go and do what he sayeth in his commandments that we should follow, in order, to enter the Kingdom of Heaven. As the years went by I became lonely. Again we are human and I felt that I would like to meet a mate to fulfill my life once again. However, we have to be careful, because Satan has a way to infiltrate our lives and cause us to go astray from God's word, by sending us someone that may bring us misfortune! I knew I did not want to be in a relationship of "shacking," but to marry once again. So as I prayed to God not selfishly but with sincerity that I would meet someone to love, respect and trust. Some weeks later, as I was grocery shopping, I looked up from my cart to see a man with the most wonderful smile I had ever envisioned! He

spoke and it kind of took me aback, but I was able to mutter a "faint hello." We talked briefly and I found out he was a widower and I informed him that I was divorced. Before we left to continue our shopping, he asked for my phone number, which I could hardly remember! He was the kind of man that everyone who met him, instantly fell in love with him. We had that instant attraction and I knew that this was the man, I would spend the rest of my life with, he was my "soul mate!"

Beloved, do not believe every spirit, but test the spirits, whether they are of God; because many false prophets have gone out into the world.
- 1 John 4:1

When finally introducing my new found love to my daughters, I was a little apprehensive and hesitant to do so. What if they did not like him or approve of this relationship that was developing? Early on, even though they were young in age, I always valued their opinions. But with that flash of that winning smile, he gave the girls, I immediately knew from the look on their faces that I had their approval! BINGO! When we finally announced to the girls that we were going to be married they were ecstatic and jumped for joy. My youngest daugher had a certain wiseness about

her and she was a hard nut to crack when it came to accepting people; so to see her so excited about the upcoming marriage, I knew in my heart, I had met the right man. She was so thrilled that she told anyone who would listen that "we" are getting married! She asked me what our new last name would be and I explained to her my last name would change, but theirs would remain the same as their fathers'. She excepted it even though she thought it was crazy for a child not to have the same last name as their mother. That was my "expressive child!" I knew without a doubt, God had put her here to take care of us all! She just had that inner being of nuturing, which we all tend to need. Even though I divorced their father, we still remained civil to one another for the sake of our girls. Once again, I put all my trust and faith into God, our heavenly father, that I was making the right choice.

You, beloved, building yourselves up on your most holy faith, praying in the Holy Spirit, keep yourselves in the love of God, looking for the mercy of our Lord Jesus Christ unto eternal life.
- Jude: 20-21

Our lives soared to the the highest heights, as an eagle taking wings to fly to a new destination. The wedding was plannned, the girls were such troopers as they helped with the arrangements. The wedding day came and went just as fast as the snap of a finger! It was such a perfect day on that cold, snowy , crisp winter day in December. We both simply adored Christmas, so we decided to have a Christmas wedding! As we recited our vows and pledged our love to one another, I whispered a secret prayer to God that I would work at this marriage to make sure it lasted forever. I can still hear the echo of Diamond singing "Here and Now" by Luther Vandross. Ringing in my ears was, also, a statement that Rev. T.D. Jakes made: to make a marriage work, you must have the same "core values!" I interpreted this to mean that, we both had to have God in the center of our relationship and each have worthiness, respect and love for one another. We needed to always remember that we were now one and that was the most important thing that would help our marriage survive. Also, we needed to have that compatibleness and always beable to bridge the gap with open-communication. I must say he and I worked at this marriage by keeping open communication and the marriaged turned out to be even stronger than we ever thought possible! He was indeed my "soul mate!"

This Book of the Law shall not depart from your mouth,
but you shall meditate in it day and night, that you may
observe to do according to all that is written in it.
For then you will make your way prosperous,
and then you will have good success.
– Joshua 1:8

Even though we think we have the "total package," we need to be aware of our surroundings at all times, stand on a firm foundation and stay focused and prayed up. Because at the "twinkling of an eye," life can be snatched from us, just as it was given to us. We do not need to take things for granted and thinking nothing will ever happen to us, because life if full of "slam dunks," which come when you least expect them! After thirteen blissful and fun-filled years our marriage ended when God called my husband to come home with him! It was as if he were gone at "blink the of an eye!" He was killed in a trucking accident on his way to make a delivery. This completely devastated me. If it were not for my two daughters and family, I don't know how I would have survived. Because at that time I wanted God to take me, too. Was that being selfish? Was that not trusting in the Lord? Does He truly not make mistakes? Had I for gotten to put God first and foremost in my life? Nu-

merous questions flooded my mind.

I always talked to my husband every morning before I went to work and several times in the evening before going to bed. This had been our ritual for the last thirteen years. We never grew tired of talking to one another. It was our "treat!" As was each time he would return home, after a week or two on the road. It was like a honeymoon that never ended. This particular week when he arrived at home, he seemed a little more fatiqued than usual and no appetitie. That was a first, because he was always hungry, he was a lover of home-cooked food, as he called it. Since he always ate at resturants and truck stops ninety per cent of the time! He complained of how his body ached all over, especially his left arm, which hurt constantly. I insisted that he see his cardiologist, but he said not to worry he had an appointment in a couple of weeks. Of course I worried, since several years prior to this incident he had a heart attack while working. During that time he was hospitalized and at home several months recuperating. So I made him promise me he would relax and rest for the remainder of the week-end. The next day to pacify me, he went to his primary physician and was given pain medication and told to rest! However, the following day when I returned from work, he was no where to be found! I immedi-

ately called his cell phone to find out where he was. He informed me his boss had called and said he had no one to take a load, would he do it? Of course his employer knew he would not say "NO!" He assured me he felt better and he would rest whenever he wasn't driving. I STILL WORRIED! And thought, What in the world is next?

You will keep him in perfect peace, Whose mind is stayed on You, Because he trusts in You. Trust in the Lord for-ever, For in YAH, the Lord, is everlasting strength.
- Isaiah 26:3-4

This was my thirtieth year teaching and I had planned to retire. I did not tell him when he was home, because I wanted to surprise him. I had planned to spend a little time riding with on his "rig!" So that particular morning, as I drove to my job site to fill out my retirement papers, I recieved a phone call on my cell phone. It was my husband's boss giving me the tragic news...Your husband has been in an accident, immediately, I asked where and I'm on my way? He said I'm sorry, he didn't make it! I let out a loud shrill, which in my ears, sounded like a wounded an-imal!!! Remember now, I am driving on an interstate highway! However, I had to pass my parents' house

before getting to my destination. I whipped my car into their driveway, honking the horn and screaming! During this time, my father was a farmer and he came running across the field... as he opened the car door, I fell into his arms. Everything was a blur, from that point on. Plans being made to fly him home, plans being made for the funeral, people coming and going paying their respects, the funeral service, the burial ground, trying to force food down and trying to be strong for both of our families, since I had, also, inherited several step-children. I must say once again, my collegues from school were there for me! I guess this, too, is a family of friends that will be there for you, whenever, in your time of need. Since he was a truck driver and loved by all, we had his funeral at the middle school where I taught because it was much larger than my church. I can never repay my faculty members, they handled everything. Only God helped me through this terrible ordeal. I was angry at Him for taking away my husband which I thought was much to soon! But I realized God makes no mistakes! Everything happens for a reason! Once again in my life, I had such pain and suffering, the kind I wish upon no one! The questions still flooded through my mind quite often, why him? why us? what will I do now? how will we go on? Yes, for a while I asked these

questions daily. Then one night I awoke in the wee hours of the morning jerked awaken by a dream I was having! I got up and went outside to sit on the steps. Something was drawing my eyes up toward the heavens. As I cast my eyes to the right there was a "bright" star blinking, as if it were winking at me! I whispered my husbands' name. And it seemed as though he whispered back to me saying, "don't worry about me, I love you but now I am okay no more pain or suffering, I am with my heavenly Father. Thanks be to God!" He ended by saying remember the poem you inscribed on my funeral program and in my casket, go back and re-read it and you will know I am well with my Lord! I could hear his laughter, which I had grown to love, as the star disappeared!

Footprints in the Sand

One night I dreamed I was walking along the beach with my Lord. Many scenes from my life flashed across the sky.

In each scene I noticed footprints in the sand. Sometimes there were two sets of footprints, other times there was one only.

This bothered me because I noticed that during the low periods of my life, when I was suffereing from anguish, sorrow or defeat, I could see only one set of footprints, so I said to the Lord,

"You promised me Lord, that if I followed you, you would walk with me always. But I have noticed that during the most trying periods of my life there has only been one set of footprints in the sand. Why when I needed you most, have you not been there for me?"

The Lord replied, "The years when you have seen only one set of footprints, my child, is when I carried you."

- Mary Stevenson, 1936

My life continued with an empty void in one part of my heart! The loss of my husband touched me in a way that I can never explain. Death as I stated earlier, means the end and destruction. Even though it was the end for my husband, I knew that I had to go on with my life for my daughters, knowing in my heart he would want me to live life to its fulless. That's just the kind of person he was. I had to pray constantly, in order, to keep my sanity. My family rallied around me at all times; they were helpful, sympahtic and consoling when I needed it. Jokesters when I needed to laugh and they just reminded me constantly that my husband had been a kind, loving, giving and joval person and that his spirit would be with me forever!

Psalm 27:5 For in the time of trouble, He shall hide in His pavillion; In the secret place of His tabernacle. He shall hide me; He shall set me high upon a rock.

Arising from my childhood, and being there in my time of need, was my cousin Diamond. My youngest daughter refused to return to college because she did not want me to be left alone during this time of my grieving. I reminded her that my husband had always taken great pride in her and stated that his youngest daughter would be the first of all

his children to graduate from college. I told her for him, she had to go back and finish her education. So Diamond, a precious jewel, stepped up and moved in with me. We reassured my daughter that I would be fine and Diamond told her she had everything under control. We promised to call and keep her informed of how things were going. We didn't have to worry about calling because she called each and every day and when not in class or studying on week-ends she would drive home. Diamond talked to me, watched me cry, allowed me to vent, wiped away my tears, made me laugh at the silly things my husband had said and did! Through her nuturing, consoling and caring for me, I became stronger each day and I made it through with her and the empowerement that God laid upon me. The emptiness and broken-heartiness was still there, but I knew with the help of God and His strength and power, I would make it and become a stronger "Black" woman! Thanks be to God! Once again that question crept up in my mind: What in the world is next?

The Lord watches over the stranger;
He relieves the fatherless and the widow;
But the way of the wicked He turns upside down.
- Psalm 146:9

Part Four

I still retired after my husband's death, even though my principal and co-workers begged me to stay on to continue my teaching career with them. I felt through all that had happened it was time for me to move on and start "fresh." I had given thirty years of service to teaching and I was only 52 years old, so I did feel that I wanted to work a while longer. Once again, I acqiured a full-time teaching position at a state correctional institution. I really lucked up on obtaining this position. During my last two years of teaching, I had the "empty nest syndrome." My husband was a truck driver and over the roads of the U.S. nintey per cent of the time, and my daughters were away at school and working. I seemed to have way too much time on my hands. One Sunday after church, I stopped at a local convenience store and purchased a newspaper, to browse through the want-ads. I had been praying and debating about getting a part-time job. I now laugh, the workalholic in me and I had the nerve to talk about my husbands! As I read through the advertisements, I immediately stopped! "Wanted GED teacher position@ the state's local correctional institution from 5-9 p.m. Contact your local community college." I knew God had answered my prayer and it just felt right to pursue this job!

*In You O Lord, I put my trust; Let me never be put to
shame. Deliver me in Your righteousness, and cause me
to escape; Incline Your ear to me, and save me.
For You are my hope, O Lord GOD;
You are my trust from my youth.
- Psalm 71:1-2,5*

Quite naturally, I had to consult and discuss this issue with my husband and my two daughters. We tended to make no decisions without talking them over! Of course, he stated if it makes you happy, then go for it and of course my daughters were ecstatic at me being so adventurous. At that instance, my love seemed to flow even more for them. This opened line of communication that we always envisioned to have was great and it kept us together as a family unit. So with all my bases covered and their approval, I interviewed for the position and was hired that same day! Once home, I fell on my knees with out stretched arms and thanked my Master above! I do remember my husband reminding me to be careful, since I would be working there at night. You see my husband was such a unique kind of guy who knew just the right things to say and that beautiful smile seemed to seal everything up! He always wanted to please me and my daughters, his children and both sides of our

families in any way possible. I smile when I think of him being home on some Sundays, we would all always go to church together and he would say, to God; David, your chosen one is here today and give us that broad grin. He enjoyed good preaching, good singing and just praising the Lord!

I thank my God upon every remembrance of you.
- Phillippians 1:3

So after I retired and my husband deceased, I applied through the state for a full time position at the correctional institution. Once again, I interviewed for the full position and I was hired. Everyone was friendly and they welcomed me with open-arms. And guess what? One of my former student teachers was the principal! How much more could I possibly have asked for. It seemed as though everything was falling into place. My Memaw told me at an early age that I would go far because "I could talk the iron legs off of the tea kettle!" And talking was my saving grace.

The Lord will guide you continually, And satisfy your soul in drought, And strengthen your bones; You shall be like a watered garden, And like a spring of water, whose waters do not fail.
- Isaiah 58:11

The GED program was housed in three different schools which were inside of the institution. The schools resembled the public schools, only in a prison setting. There were over 5,000 inmates in this institution and the government had mandated that anyone without a high school diploma or a GED, had to attend the schools for at least 120 days. When attending these classes, you had to take the basic courses which were reading, language arts and math. These classes would prepare them for the upcoming tests, in order, to obtain a GED, which evenually changed to an actual High School Diploma. If they desired to continue their education, they could. There even were a few local colleges who offered classes to the inmates who wanted to take college courses. Also, there were different types of vocational classes offered... computer, carpentry, automative, graphics, and several more. There were many options given to the inmates for them to be able to leave and enter the world as a productive citizen. It was up to them to grasp hold of the education given and to make the right choices. Hopefully they would continue to walk a straight path once reunited with society and not return to prision. The reacurrence of them returning to prision was quite high, since many of them were instituionalized. Many wanted to come back because they had no

where to go, many times their family members had died or moved on with their lives and many were just rejected by society!

Even with all of the barriers and hardships that these inmates endured daily, the power of God, was definitely in that place! In the time of need and trouble no matter who or where you are, the first person we call upon is our Heavenly Father. Man may leave you and lead you astray but God is always there waiting for us to call him. His line is never busy! He is there to forgive, help and give us guidance to fulfill our every need! There were several ministers of many different denominations, who offered their services to meet the numerous inmates. These ministers regardless of their faith or denominations were a God sent to the inmates who needed help with the empowerment of their faith. Jesus wept. John 11:35. He did weep for us and we weep, also, to him in our times of need and sorrow! And Jesus wants us to know, if we believe we will see the glory of God! We are all human and tend to go astray, just as those many inmates had done. So we need not judge them because we are all sinners, saved by the grace of God. Remember evil comes from within the heart! We need to guard our hearts each and every day! Even though there were correctional officers on duty guarding the inmates,

God sent his messengers, those ministers to guard the hearts of those inmates!

Anxiety in the heart...causes depression,
but a good Word makes it glad.
– Proverbs 12:5

Teaching has always been one of my passions. I loved to see the students succeed and grasp hold the given subject matter and take it to the next level. These inmates were no different than any other student I have ever taught. Once again I took a life-long slogan to the inmates, "Knowledge is Power!" Many of them actually adopted that slogan as their own and constantly referred to it in thier discussions with one another. One elderly student in his late seventies once stood up class when there was a confrontation between two other inmates in the class and said, we have wasted enough valuabe time in our lives, you all need to remember "Knowledge is Power!" That was my first positive experience with inmates. For someone to actually be brave enough to stand up and say this in a prison, lets me know someone has been touched by God and is ready to recieve his blessings. Many of them seemed to have a thirst for learning. Many of them had just made wrong choices in life. Many of

them acknowledged that they had committed crimes for the wrong reasons: my mother was never home she was a prostitute and my sibliings needed food, shelter and clothing; my girl friend liked the finer things in life, the bling-blings; I was molested by a family member at an early age; I was physcially and mentally abused by mother's long trail of live in boy friends; and on and on! The reasons why they were there were numerous in number! But whatever the case was, they were now willing to get an education and try to make a change in their lives. As I went about preparing them to get the needed skills for ob-taing their GED or High School diplomas, it was not easy with ages ranging from age 17 to77 years of age and sometimes older; to study or even concentrate because of the many obstacles they had to deal with daily being institutionalized. However, even with the many road blocks they encountered, many were able to weather the storm and graduate! There were some days we did not teach a lesson, because they needed to vent and talk about some problem they may have met up with...my mother died, my son is in the hos-pital very ill, my wife is filing for divorce, last night I didn't sleep due to my "celly" being sick, and so on. Again, they needed to feel that someone cared and I truly did! They were my students! We did have a

graduation every year for them with cap and gown. During this time their level of confidence seemed to soar! This was the highlight of their lives, to actually make such a great accomplishment! They were able to invite family members, even their children were allowed to come. It ended with a reception where they would even introduce "us," their teachers to their family members. Many stated if it not had been for the patience these teachers had, we would not have made it. Imagine how it made us feel! No matter where you are or who you may be, everyone wants to make their families and themselves proud that they were given the power from God to succeed! All we have to do is reach out and grab it. It is there for the taking! Just trust in the Lord and he will bring you out!

But the salvation of the righteous is from the Lord; He is their strength in their time of trouble. And the Lord shall help them and deliver them; He shall deliver them from the wicked, And save them, Because they trust in Him.
- Psalm 37:39-40

Though several decades of my life have handed me many challenges as a black woman, a black teacher, and a young black girl from a rural and remote

area, the power of God has blessed me more and more each and every day! I have faced many hardships, turmoils, struggles, disappointments, fruitless adventures, and many sit backs, but "through it all," I have learned to trust in God and to put Him first and foremost in my life...He is a mighty fortress! He is my solid rock!

The power that God has entrusted in me with the combination of trust and faith in him has caused me to continue to move forward. This power has enabled me to have the neccessary coping skills needed to give me the strenghth to continue and press on with this journey. I have seen man leave love ones, but God with his great and mighty power will always be there for you and never forsake you. It is very easy for folks to say don't look back, look forward to whence you cometh, and not at what has happened in the past, but the past is a stepping stone into the future. We are reminded not to look back as a comparsion of the city Sodom and Gomorrah; what happened to the wife when she looked back and was directed not to. Genisis 19:1-38 Yes, this is true, however, the flesh is weak, we are all human and tend to go astray and have those power struggles almost daily! During these struggles it seems that on one shoulder we have satan standing tall but rooted and on the other shoulder is God

the almighty standing as a "solid rock!" Satan rears up and says go ahead do whatever you want to there will be no conseqences for your actions and on the other shoulder God so patiently is saying "stop, look, and listen to my words follow them and you shall have life everlasting!" In life we definitely have daily power struggles, so we have to pray with sincerity at all times and strive to make the right choices. Even though we may struggle and go astray, remember that it says: let not your heart be troubled or your faith be weakened, continue to trust in the Lord and he will surely bring you out! I feel that the past is a stepping stone into the future! So lets order our footsteps and continue on the right path and you will reach your goals or come very close to them.

And he who overcomes, and keeps My works until the end, to him I will give power over the nations.
- Revelation 2:26

Ladies, something amazing has been transformed! Suddenly you have the power to shape the future you want. The old cliche of "climbing the ladder of success" is here. Just do it! We have been empowered to have the knowledge and power to succeed at anything we strive to do in life. Sometimes the women you look to for advice are the ones who most likely

have gone astray but picked themselves up, brushed their clothes off and forged onward. Remember those "Baby Boomers!" We were radical in the 60s and 70s: sit ins, rallies for almost any cause--education--better jobs, civil rights and yes we smoked pot! We did it all for obvious reasons: some for the promotion of better living conditions, better schools, better jobs and some for pleasure. However, we never forgot the making of our dreams coming true even if it was on our terms we continued to strive to make our lives better and our dreams come true.

Our first lady, Michelle Obama wants you to feel this empowerment, also! Michelle is one who I have grown to respect, admire and love. Girls, you will be women one day, so hold your heads up high, get the best education possible, guard yourselves when selecting the right mate and you will go far.

Michelle states, "Girls sometimes think words like power have nothing to do with them-but that couldn't be further from the truth. The truth is being yourself is POWERFUL! Doing the things you love, whether that's coding an app or writing a poem or earning money for college at an after-school job is POWERFUL! Helping others whether it's a younger sibling with homework or reaching out to folks struggling in the community or standing up for

a classmate that is being bullied, is POWERFUL! And most of all, committing to your education and working as hard as you can is POWERFUL, because that's how you will ensure that you can be anything you inspire and make sure your voice will be heard in this world."

So I must say, many things have occurred in my life that I have pieced together as a puzzle and it has enabled me to continue to grow into a POWER-FUL BLACK WOMAN. I know that many more obstacles are out there waiting for me, but I will continue to put my trust in the Lord and humbly and say, "Lord give me the power to accept the things I cannot change." Remember God makes no mistakes! So when things happen, painful situations, life seems too intense, your neighbors turn their backs on you, your child goes astray, and we do not understand why, just remember God makes no mistakes! I find myself contining to whisper often:

WHAT IN THE WORLD IS NEXT!

And he who overcomes, and keeps My works until the end, to him I will give power over the nations.
- Revelation 2:26

Afterword

As a young female coming from a rural area and entering college in a large city, there was a bit of doubt and dismay about leaving the safety of my nest—home. Even though we were nurtured and taught right from wrong, there is still that feeling of wanting to fit in with other students. These students were from all realms of life. Some very street smart, some as I was called, a country bumpkin, some thugs, quite a few nerds, and others just plain old plain ... Meaning they really fit in no where.

This book is a realistic fiction with some facts that happened in my life. After writing this book and taking the journey of my life and recapping various avenues, I encourage all of you to tell your story. Remember we all have a story to tell. I must say, I feel such an uplifting in my heart after telling my story. Life has truly been good to me. As I look back from whence I cometh, I am in awe with my accomplishments. There were a few obstacles that hindered me along the way, but thanks be to God, I overcame them.

If you remain persistent and strong in your faith and continue to pray unconditionally, then God will surely grant you serenity and peace. God yearns for us to seek strength and through prayer as we encounter

our many difficulties and are presented with joyfulness. We will find that prayer is the key that will unlock the door to our success.

I will continue to be obedient and trust in the Lord. After all, our Creator knows the struggles we face. He knows how much we can bear and He will not put anymore on us than we can take. God gives us a "mighty sword" to fight our battles with and we can go through life's challenges on our own or we fight our battles with God! We can follow God's plan for us or make our own! But we as humans tend to make a mess of things, therefore, I would advise you to read His "mighty sword" and follow His Word. He will never fail you or leave you!

From time to time, we often pray about a situation and feel that God does not hear us or maybe the issue we are praying about is so bad he is punishing us. Regardless of how we may feel about a given situation or an act that has happened to us, God does not want us to be fearful, upset or feel that we are alone. He will answer you in due time. You will have to wait on Him and put your trust in Him.

Each of you should use whatever gift you have
received to serve others, as faithful stewards
of God's grace in its various forms.
- 1 Peter 4:10

Forgiveness Will Set You Free!

The angel said to the women, "Do not be afraid for I know that you are looking for Jesus, who was crucified. He is not here; he has risen."
- Matthew 25:5-6

CPSIA information can be obtained
at www.ICGtesting.com
Printed in the USA
FFHW020808110919
54903493-60599FF